COMPLICITY

First published 2022 by order of the Tate Trustees
by Tate Publishing, a division of Tate Enterprises Ltd,
Millbank, London SW1P 4RG
www.tate.org.uk/publishing

Photo credits
All images © Tate Images 2022
National Trust Photographic Library / Bridgeman Images p.39
© Stephen White & Co. p.20–21

A catalogue record for this book is available from the British Library
ISBN 978 1 84976 826 9

Distributed in the United States and Canada by ABRAMS, New York

Library of Congress Control Number applied for

Senior Editor: Alice Chasey
Series Editor: James Finch
Production: Juliette Dupire
Picture Researcher: Roz Hill
Designed by Narrate + Kelly Barrow
Colour reproduction by DL Imaging, London
Printed in Wales by Cambrian Printers

Front cover: Neil Kenlock, *Demonstration outside Brixton Library* 1972
(printed in 2010) (detail), see p.25

Measurements of artworks are given in centimetres, height before width,
before depth.

COMPLICITY

JAY
BERNARD

Director's Statement

'Look Again' is a bold new publishing programme from Tate Publishing and Tate Britain. In these books, we are providing a platform for some of the most exciting contemporary voices writing today to explore the national collection of British art in their own way, and reconnect art to our lives today. The books have been developed ahead of the rehang of Tate Britain's collection, which will be launched in 2023 and will foreground many of the artworks discussed here. In this second set of texts – *The Sea* by Philip Hoare, *Complicity* by Jay Bernard, *Fashion* by Shahidha Bari and *Visibility* by Johny Pitts – we are offered unique perspectives on a wide range of artworks across British history, and encouraged to look closely, and to look again.

Alex Farquharson, Director, Tate Britain

'The cemeteries were bigger and had more life than most of the towns I knew. You could walk on a Sunday from West Norwood, where I lodged, through Streatham and Tulse Hill, Brixton and Kennington, to the river, to the Tate ...'
Iain Sinclair, *Lights Out for the Territory* (1997)

'To be able to do evil shit and still call yourself a thinker'
Fred Moten

That sensation is back. Susan Howe, in *Spontaneous Particulars: The Telepathy of the Archives*, calls it 'inward ardour' – this buoyant, purposeful feeling as I descend the slope from Henry Tate's mausoleum in West Norwood Cemetery and begin my walk across South London. I am heading to the tomb of Henry Tulse in the City of London, and I am eager to get there for reasons I can't yet articulate. This lack of articulation – spread over twenty pages of notes around the idea of *complicity* – engendered my decision to move where I couldn't speak, to document where I couldn't invent. Why spend any more time *thinking* around a word like *complicity* when you could go and feel it? London, which Peter Ackroyd describes as a place of 'mercantile aggression', was once the heart of an Empire, and the resonance of those old epochs, of Lord Mayors and the Royal African Company, still radiates from

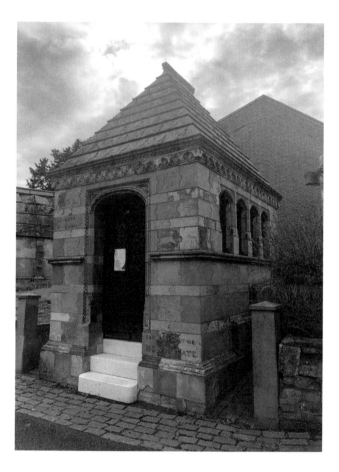

Jay Bernard, Henry Tate's Mausoleum, West Norwood Cemetery, 2021

the centre. Here, this city I love, is where the old generations of my family were abstracted, reduced to shares, bonds, stocks. Tulse traded slaves and chaired the Royal African Company, Tate traded sugar of dubious provenance. I can't imagine living anywhere else.

I leave the cemetery gates with a white rose in my buttonhole. It comes from my Uncle Derek's grave; I didn't feel it was right to visit the mausoleum of a dead Victorian, and not the very sweet man who had given me pound coins as a child. When I show the grave in its current state to my mother, via FaceTime, there's an anguish in her voice. 'No-one's been there for ages. Poor Derek, man.' She says there's a spade somewhere, but I can't find it, and instead clear the grave with my hands. Tin foil from someone's sandwich. Coffee cup. For the second time in an hour, I feel a sense of having fulfilled a duty. What if I came here more often? Trimmed the rose bush, polished the headstone? Are we ever more Good than when we tend to the dead? I take one of the roses and try not to think about the sadness in my mother's voice. I knuckle down, and off I go.

West Norwood, where I leave the cemetery gates, is lauded as a southern Highgate, being one of the great Victorian parks. The area, which was countryside before the mid-nineteenth century, has

"ARE WE EVER MORE GOOD THAN WHEN WE TEND TO THE DEAD?"

that leafy, premeditated feel you get in Hampstead Heath or Kentish Town. In those places, despite all the patisseries and charcuteries, I often feel like I have stepped on Someone's Nature, and that these places feel 'natural' because they're a lasting demonstration of what nature came to mean: artificially designed, for a wealthy middle class, as seen through the church window. No tree just stands there, no, it earns its place! I try to imagine the original North Wood, or England before its deforestation project was complete, or even what a true common would have felt like. I try to imagine the dirt track I would have followed, which is now flanked by Greggs and B&Q, smutty Georgian and tatty art nouveau façades. Further back is my dad's antiques shop but, for the same reason I try not to recall my mother's voice, I decide not to visit. Better to press on.

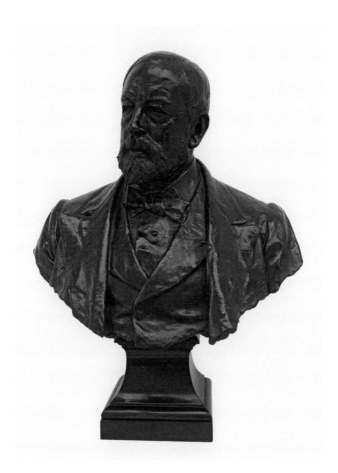

Sir Thomas Brock, *Sir Henry Tate* 1898, bronze on stone base,
53.3 x 58.4 x 35.6, Tate

"ESTATES LIKE CRESSINGHAM ARE A REMINDER THAT ENCLOSURES ARE STILL TAKING PLACE; THAT TULSE HILL WAS BUT A BUMP IN A GREAT WOOD DURING TULSE'S TIME, AND THEN, BIT BY BIT, WAS CHOPPED DOWN, SOLD OFF."

Post-pandemic, many of the shops near Tulse Hill station are closed. Dereliction is a strong word for any part of London in the twenty-first century, because all empty space is just future luxury flats. This junction is relatively ungentrified, though I don't know for how much longer. As I come under the bridge past Leigham Vale, I feel the first atmospheric shift: the A205 makes this liminal point feel like a dirt bike rally. I turn up Christchurch Road, once a parish in this region, and follow it round to Tulse Hill itself. It has little going for it besides the housing estates, its proximity to Brixton and the fact that it backs onto Brockwell Park.

People started calling it Tulse Hill informally at first, because Henry Tulse owned a lot of property there.

One of his three manors, Bodley, gives its name to a path in the Cressingham Gardens Estate. It's one of those places I can't make up my mind about – John Major okayed it when he was a local Conservative councillor in the late 1970s (there's a blue plaque that says as much), and you can see how it was an example of experimental thinking. Yellow brick, small square windows, large open gardens, random grass. But there's no clear logic to it: paths lead to stairs and stairs lead to cul-de-sacs. Though reminiscent of the medieval passages that make London walkable (and therefore great), these hobbit holes don't make ambulatory sense.

In February, I witnessed a stabbing here – five or six boys attacked a woman as she got out of her car, grabbed her bags, then disappeared into the estates. Since then I have felt unsettled walking through these semi-subterranean tunnels, yet also felt angry about the posters someone has printed and dotted about, saying 'Save Cressingham Estate!' Because this is juicy land, right by Brockwell Park, occupied by ordinary people, so of course, it's marked for destruction. I mean demolition. I mean *enclosure*.

Estates like Cressingham are a reminder that enclosures are still taking place; that Tulse Hill was but a bump in a great wood during Tulse's

time, and then, bit by bit, was chopped down, sold off. Developers now expect one- or two-bedroom flats on this land to fetch half a million pounds each. Despite growing up less than a mile from here – among the working class who paid for their homes with ordinary jobs – I have almost no prospect of living here again. Unless, that is, I win the lottery, or do something regretful that will earn me a lot of money. Sometimes desiring a house feels a little like wishing for fame.

Keith Coventry, *East Street Estate* 1994, oil paint on canvas, wood and glass, 112.7 x 82.1 x 5.5, Tate

"I REALISE THIS MIGHT BE THE FIRST TIME I HAVE FELT ANXIOUS FOR MY IMMORTAL SOUL."

Further down, the two Henrys finally overlap – though not in the way I expected. Family Club is a nursery housed in an old nurses' home gifted to the Brixton District Nursing Association by Henry's second wife, Lady Tate, in 1906. When I first moved to the area, I noticed how fancy it looked and checked out the fees online: *a child under three, full time, £1,818.20* per month. State funding can bring it down to £456.30, but it's still a massive single expense, even for two working parents. In the cemetery I'd written in my notebook: 'I am a generation who will likely have no posteriority ...' In my thirties, in the most expensive city in the world, the irony of the situation strikes me: my ancestors went through *all that*, got to London, only for the family line to terminate at Zoopla. I wonder if this

isn't part of what excites me about memorials, archives, local history: I recognise the desire to be remembered, and have a sneaking suspicion that I won't be, hence the imperative to develop a praxis of memory that isn't reliant on genetic family ties. I am sure many dead writers are grateful for the literary enthusiasts who leave Lamy pens on their graves. Heading towards the Effra Road, I realise this might be the first time I have felt anxious for my immortal soul.

I am on the last stretch before I hit Tulse Hill's more famous cousin, Brixton. Above me is a mural by an artist called Vibes, in which Brockwell Park is rendered in apocalyptic purple. To my right, the chip shop my dad has proudly frequented for thirty years (I told him that's how diabetes occurs). Hootananny's is relatively quiet at the moment, but the smell of barbecued chicken is intoxicating.

Brixton comes up when you search the Tate Archive catalogue, but Tulse Hill does not. Among the results are Mona Hatoum's *Roadworks* and *Performance Still* 1985/1995.

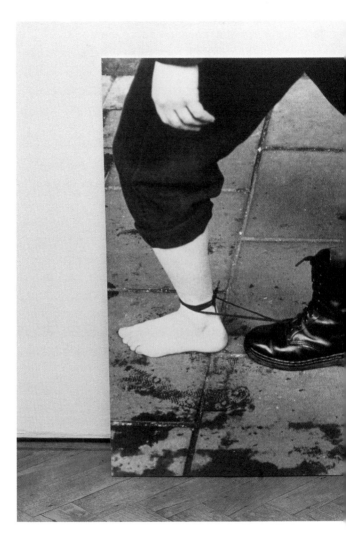

Mona Hatoum, *Performance Still*, 1985/1995, gelatin silver print mounted on aluminium, 76.4 x 108, Tate

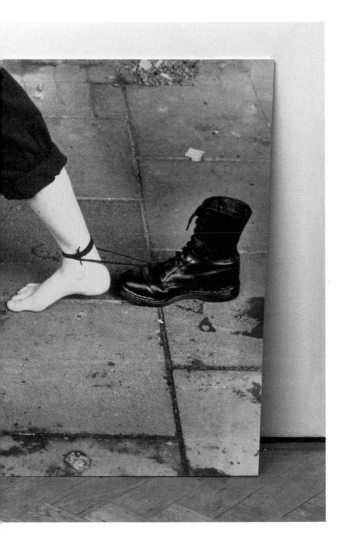

"THIS THING OF BEING ENSNARED IN THE MECHANISM OF THAT WHICH PERSECUTES YOU AND PEOPLE LIKE YOU, WALKING ITS STREETS, BEARING ITS PSYCHOLOGICAL WEIGHT."

Small bare feet tied around the ankles to a pair of Doc Martens. I remember seeing video documentation of the 1985 performance *Roadworks* at Nottingham Contemporary, where I was intrigued by its openness. The performance piece was a response to the heightened police presence after the 1985 uprisings against racist police brutality – that pair of Doc Martens represents the police. But I begin to think they might depict a stranger relationship: an internalisation of state violence, with the laces and the ankles and the dragging being an external representation of the inner disjunct that follows. Both *complicity* and *compromise* come to mind: the shoes have no person, and the person has no shoes. Each implies

the other, and are inextricably tied. It's a yin-yang enfolding. Hatoum is British-Palestinian, and suffered the realities of displacement, ending up as an exile in the heart of the same Imperial power that helped engender the Naqba. This thing of being ensnared in the mechanism of that which persecutes you and people like you, walking its streets, bearing its psychological weight. It is not that we – migrants, refugees, racial minorities – are complicit with the British state simply by existing here, but that the network of power relations that entangle and compromise us appears more finely grained. It is not just the threat of violence that we drag behind us, but the constant anxiety about our own collusion with what the boots represent – how much and how intimately we integrate; how much of history we disregard or bring to the fore; what actions will or will not allow us to live with ourselves.

When I hit Brixton's Windrush Square, I sense I will never reconcile these feelings I have – this sense of wrongness about being in this time and place, coupled with this *ardour*. To be the target of a right-wing hostility, engendered by Brexit, yet entangled with this city and its ghosts. Windrush Square has become a kind of memorial graveyard over the years. Most recently, there's the Cherry Groce Memorial, a pavilion dedicated to the woman whose shooting sparked the 1985 Brixton riots.

There's the big Bovril sign, the African and Caribbean War Memorial, the Brixton Black Cultural Archives, the bust of Henry Tate, the Sharpeville Massacre commemorative stone. I think it's the most culturally Victorian thing that we still maintain – statues, busts, plaques everywhere, public life fashioned after the interior of the parish church. Brixton is a triumphant place in many ways, but in real time you can see the contradictions of the present moment – particularly gentrification – that an act of memory cannot address. There are war memorials on every corner in South London, in England, each one naming a postman or a police officer or just a Lambeth resident; the fact that they are everywhere, and so prolific, tells me that the power is not in the memorial itself but in the act of creating it. That by the time it reaches its stone base or a ribbon is cut, the main reason for doing it has already been achieved. That there is a private, unknowable, personal dimension to this pursuit, which, when placed in public, takes on the same mysterious qualities of the headstone and the grave.

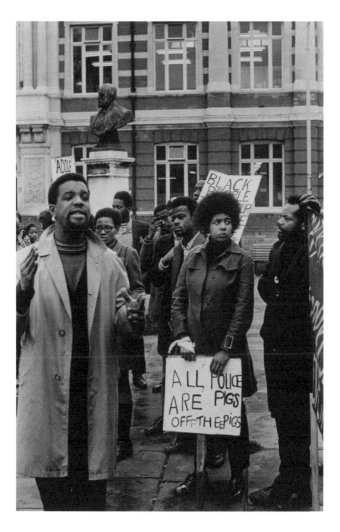

Neil Kenlock, *Demonstration outside Brixton Library* 1972 (printed in 2010), photograph, gelatin silver print on paper, 38.3 x 25.3, Tate

I decide not to eat in the market, and instead get some Lebanese bread and juice from Pop Brixton. I never usually come here because I find the politics and economics of the whole enterprise distasteful: I can remember when it was an empty plot of land, and a tiny A4 sheet was stapled to the fence asking the public for suggestions about how to fill it. Presumably those suggestions came to nothing.

A young boy with very dark skin arrives, flanked by two much older-looking white people. They seem official, like the boy is in their charge – I wouldn't say their care. The woman talks and talks and talks, yet I can't make out anything she is saying. The boy avoids her eyes, responds respectfully, but coldly. It's like she's trying to convince him of the wrongness of something he previously thought or did. It unsettles me. I think about Georgian London, enslaved kids being pets for the aristocracy, then cast out once they stopped being cute. Such children are everywhere in British art, if you care to look. I have no idea what this boy's situation is, but the nature of this walk means my imagination is veering into something dark, that won't necessarily serve me – so it's time to continue.

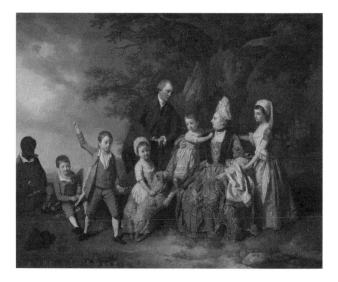

Francis Wheatley, *A Family Group in a Landscape,* c.1775, oil paint on canvas, 116 x 141 x 8.5, Tate

"THIS NEW DECADE HAS THE GRAVITATIONAL PULL OF A CENTURY TURNING, AND QUESTIONS ABOUT WHO AND WHAT WE ARE ARE GETTING LOUDER AND MORE URGENT."

I walk past Brixton Leisure Centre onto the main road, where an old Caribbean man is shouting at the traffic in a comical, performative way; he seems to be delighting in the fact that not everyone will understand his patois. I check to see whether the man I always see sitting outside the house on the corner near St John's Crescent is there, and he is. He is usually alone, thoughtlessly but not poorly dressed, and always seems to be staving off some regret. I always look for him, but I don't think he notices me.

Finally I reach Kennington Park, which is littered with statues and memorials, including one with a quotation from Maya Angelou:

History, despite its wrenching pain,
cannot be unlived. But if faced with
courage need not be lived again.

And yet, I think, *and yet*. During the winter lockdown of 2021, a friend and I had spent a few afternoons here, swapping food we had batch-cooked for each other. That was a weird time; the culture instantly changed. There were cries of getting back to normal, but the pre-pandemic world we knew in 2019 had already vanished. This new decade has the gravitational pull of a century turning, and questions about who and what we are are getting louder and more urgent.

After I was vaccinated in June, my dad, an anti-vaxxer, messaged me to express his disappointment that I had taken 'their' vaccine. The implication: that I was complicit in whiteness, in a corrupt medical establishment, in a culture he did not recognise and did not wish for his children. I was once again a disappointment: a queer, posh-sounding, messy, English, alcohol-swigging jab enabler. My dad longs to be a guide, but I am not buying what he's selling. I feel spiritually adrift and *do* wish I was more receptive to him, but I'm too Western, too analytical for his brand of God-fearing Baptist Rastafarianism and/or Islamic colonial orphan schtick. He tells me regularly that he doesn't know where things went wrong.

Since childhood, I have lived with this not-so-subtle implication that I am not meant to reflect the mix

Liz Johnson Artur, *Time Don't Run Here* 2020, 26 photographs, inkjet prints on paper, overall display dimensions variable

Liz Johnson Artur, *Time Don't Run Here* 2020, 26 photographs, inkjet prints on paper, overall display dimensions variable

of cultures I was born into. And this discomfort is compounded by the fact that we live in a society in which there are no solid foundations, in which we are deeply, physically aware that nothing is right. It is impossible, in modern Britain, to satisfy our own wants or needs without compromising ourselves, without engaging in the suffering of others. That is how our capitalist economic system was developed, and that is how it continues to operate. When I say that I am British, English specifically, I do not mean to express the security of cultural belonging, but the enmeshment of cultural complicity.

Mona Hatoum comes back – the wrongness of the shoes tied to the ankles, not protecting the feet. It could be that the maintenance and preservation of old things – in memorials, in statues – gives us the spiritual anchoring we long for, providing rules and rituals and ways of being that are otherwise absent from our lives. On the other hand, I think of the museums stuffed with global treasures, looted or otherwise unethically obtained, that this country refuses to give back. They are too valuable, too important to this country's identity and psychology, to be returned to their original owners!

It's about now, as I leave Kennington Park, that the world of Henry Tulse begins to emerge – the maps from his time begin here. While Tate's London is

"WHEN I SAY THAT I AM BRITISH, ENGLISH SPECIFICALLY, I DO NOT MEAN TO EXPRESS THE SECURITY OF CULTURAL BELONGING, BUT THE ENMESHMENT OF CULTURAL COMPLICITY."

detailed and systematic, Tulse's London still bears the artist's hand. I recall the idiosyncratic lines of the 1570 London map I found in the library – this route was wetter then, muddier, harder to trace. Now, the Shard is rose gold in the afternoon light and dwarfs everything with its rays. It's five o'clock. Newington Butts is amping up. My feet hurt and my knee is making subtle threats, so I do some stretches at the bus stop. I need to be careful – eighteen months of sitting at home has taken its toll – but I'm eager to get to Elephant and Castle. Apprehensive, too.

The big pink (then later, blue) shopping centre that used to sit in the middle of the roundabout (now a peninsula) has gone. When I heard it was going to be demolished, I seized my last opportunity to visit, checking out the shops and cafés. When I was a child, it was an intense place, with a bazaar-style

market in the gutter-like ring around the centre. The tunnels underneath were full of homeless people and stank of wee, but inside there was a bowling alley, an art gallery, lots of Latin American restaurants and, most noticeably for me, an immigration centre for Jamaicans. Each time I changed from the Underground to the national rail on my way southeast, I would see fifty or sixty people spilling out of the small glass office, all waiting to be seen. That patient, silent, careful way of people banking on luck – a kind officer, a benign administrative error, a humane wink. This was during the reign of Theresa May, her final summer as a harassed and beleaguered Brexiteer (back when it was hard to imagine things getting any worse). Now there is a huge hole where the shopping centre once stood. When I take a picture, I notice someone has scrawled *Fuck Tories* on the wall. Yet I wonder if the writer hadn't first looked up at these expensive new towers, and thought *fuck me*.

I pass the Faraday memorial and walk up Newington Causeway, past a group of police officers with bags full of McDonald's. A poster of Sarah Maple's artwork that used to read 'The opposite to a feminist is an Arsehole' has been altered to read 'The opposite to a feminist is HAPPY'. This is now old London, the seedy southern rump. Four hundred years ago, when Tulse was riding into town as Lord

Mayor, he would have paraded through here, up to London Bridge, across a city that was *his*. There were people that were *his* too. He did not, as far as I can tell, travel to Africa or the West Indies to kidnap slaves or establish plantations himself, but he profited from that labour in the form of shares. It's an odd thought that before electricity, before hygiene, before modern medicine, before flight, before accurate cartography, Tulse and men like him had worked out how to conjure gold. Yet in his day, it was women who were being drowned and burned for witchcraft, and Africans who were being shipped across the Atlantic Ocean to be worked to death.

Interestingly, Tulse's daughter drowned herself in the pond of the Archbishop of Canterbury's estate in Croydon in 1718, twenty-seven years after her father's death. There is a portrait of her, which survived a fire in 2015 at Clandon Park, the estate of her husband. In that portrait, a contorted face with an open mouth, like that of a gargoyle, sits behind her, suggesting something tumultuous was close to the surface. Her face is vague, her features indistinct. Tulse's portrait as Lord Mayor, meanwhile, was first identified by his coat of arms, which depicts two dolphins; before it was loaned from the Banque de France to Tate for the 2020 *British Baroque* exhibition, it had been mistakenly thought to depict the Grand Dauphin.

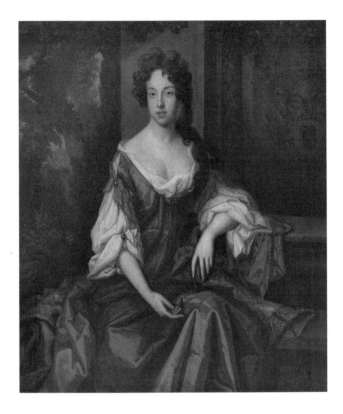

Sir Godfrey Kneller, *Elizabeth Tulse, Lady Onslow* c.1680, oil paint on canvas, 124.5 x 111.8, National Trust

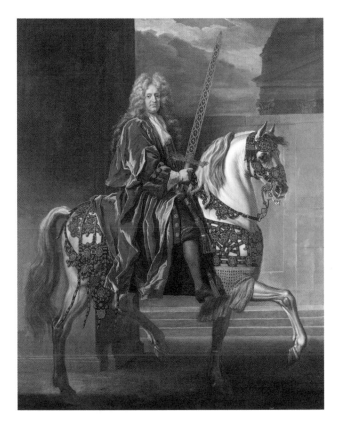

John Closterman, *Portrait of a Lord Mayor (Henry Tulse)* c.1695–c.1705, oil paint on canvas, 296 x 240, Banque de France

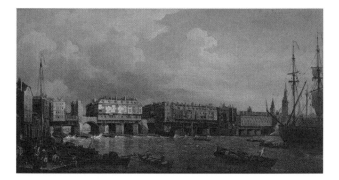

Samuel Scott, *A View of London Bridge before the Late Alterations,*
engraved 1758, oil paint on canvas, 28.6 x 54.6, Tate

All these watery associations, just as I hit
London Bridge.

The first thing that strikes me here is how much the
massive sienna building on the south-eastern side,
One London Bridge, reminds me of the pavilion for
Cherry Groce: it's that odd top-heavy triangular roof
sitting on a quadrilateral pillar. It's the wrong bridge,
but that line of Wordsworth's – 'open unto the fields,
and to the sky' – comes to mind, sending me back
to the city shown on those old maps, when town and
country were visible to each other. I feel both giddy
and exposed as I cross over, glad for such beautiful
light and interesting shadows, happy for reality to
remind me of art and not the other way around.

The walk is coming to an end. I go up King William
Street – Fish Street, in Tulse's time – then down
Eastcheap, left into Philpot Lane, over Fenchurch
Street and onto Lime Street. It takes me a minute,
but I find the plaque commemorating St Dionis
Backchurch, where Tulse was originally buried.
Apparently he wanted to be buried elsewhere, but
he did not get his wish the first or even second
time. His tomb was finally moved after St Dionis
was demolished, and now sits a few streets away in
the churchyard of St Edmund's. You have to crane
your neck and look through an iron fence to see his
plaque, laid in the 1930s by the Ancient Society of

College Youths – bell-ringers to you and me. The square is quiet and empty. I feel I have travelled through time and across oceans to meet Tulse face to face; some part of me is disappointed to find him dead.

Down the road, and two hundred years later, Henry Tate would set up his first London factory, on Love Lane, though it would not be where he developed granulated sugar or introduced the sugar cube to Britain. That would take place in Silvertown, and only after that would his and his wife's long list of gifts and donations begin.

It is getting cold. I put my shirt on and the white flower from Derek's grave falls out. My old sadness returns. I was so preoccupied with getting to the end of the walk that I forgot everything else. I need to call my parents, but not now. Right now, I want a pint in a warm pub. Before I leave, I go into the church and find an all-Black congregation: a modern youth ministry called Imprint. I wonder if they know who is buried in the churchyard. I don't disturb them, and head off into the dark of Lombard Street.

Tulse, the reason I exist in this city; Tate, the reason I am writing this essay. *Complicit* is a back-formation from *complicity*, which came straight from the French word *complicité* in the 1600s. Language had

to go backwards, swing between the time of Tulse and Tate, in order to describe a present, ongoing condition. This word, which remains unresolved on the page, is settling into my body as an ever-deeper quandary of being, place, time. *Complication*, I think as I cross the road. *Comp-location*. I imagine that one night during their lives, a strange figure appeared in the corner of Henry Tulse's eye, or of Henry Tate's, as they headed this way home, turned towards the south. I imagine that they turned and tried to get a better look, as that person disappeared down Gracechurch Street. Someone small, dark, not of their world.

"I FEEL I HAVE TRAVELLED THROUGH TIME AND ACROSS OCEANS TO MEET TULSE FACE TO FACE; SOME PART OF ME IS DISAPPOINTED TO FIND HIM DEAD."